陳式太極劍
規定套路（39 式）

掃碼欣賞正面演練

掃碼欣賞背面演練

YouTube 正面演練

YouTube 背面演練

Chen-style taiji sword
standard routine (39-form)

《國際武術大講堂系列教學》
編委會名單

名 譽 主 任：冷述仁

名譽副主任：桂貴英

主　　　　任：蕭苑生

副　主　任：趙海鑫　張梅瑛

主　　　編：冷先鋒

副　主　編：鄧敏佳　鄧建東　陳裕平　冷修寧

　　　　　　冷雪峰　冷清鋒　冷曉峰　冷　奔

編　　　委：劉玲莉　張貴珍　李美瑤　張念斯

　　　　　　葉旺萍　葉　英　陳興緒　黃慧娟（印尼）

　　　　　　葉逸飛　陳雄飛　黃鈺雯　王小瓊（德國）

　　　　　　葉錫文　翁摩西　梁多梅　ALEX（加拿大）

　　　　　　冷　余　鄧金超　冷飛鴻　PHILIP（英國）

顧　　　問：陳世通　馬春喜　陳炳麟

法律顧問：王白儂　朱善略　劉志輝

《陳式太極劍規定套路》
編委會名單

主　編：冷先鋒

副主編：邓敏佳　黃慧娟

編　委：劉玲莉　李美瑤　吳天成　许依玲　張念斯

　　　　葉　英　鄭安娜　鄧建東　陳裕平　冷飛鴻

　　　　張貴珍　周煥珍　冷飛彤　葉旺萍　陳興緒

　　　　何淑貞　戴裕強　梁多梅　金子樺　楊海英

　　　　余　瓊

翻　譯：Philip Reeves（英國）　Alex Nasr(加拿大)

　　　XiaoQiong Wang(德國)

序言
武術，源于中國、屬于世界。

欣聞學生冷先鋒近期出版發行《陳式太極劍規定套路》一書，對此表示由衷的祝賀。其實，早在九十年代初，冷先鋒就追隨我學習各式太極拳競賽套路及傳統套路，學習態度一絲不苟、認真做好每一招的細節動作，近30年一直從事武術太極拳的教學，我特別欣賞他做事兢兢業業、持之以恆，非常專心地去做武術太極拳事業，而且為人特別低調、謙虛謹慎，就算到後來他被香港特區政府以《優秀人才入境計劃》引進到香港，都會不間斷的利用網絡請教我各種技術上和教學上的種種困難和經驗，本人親眼目睹和見證了他的一步步腳印和踏踏實實的成長。

在眾多學生當中，冷先鋒算是比較年長的，卻經常會以小師弟的身份請教比他年紀小的師弟師妹們，對陈式太極拳的各種套路尤為專注，加上多年來一邊教學一邊不斷學習積累，成就了這本《陳式太極劍規定套路》的著作，他系統地從陰陽虛實、身法轉換，眼神和方位等全面地闡述了每一個招式，語言通俗易懂、圖文並茂，就算是業餘愛好者和初學者也能當入門的教程，重要的是還配有英文翻譯，更是外國朋友學習太極拳的福音。

中華武術的傳承發展與創新，離不開國家武術主管部門及廣大武術工作者的不懈努力。民族的才是世界的，希望本書的出版，能為武術早日進入奧運，增進各國武術交流，為太極拳的普及與提高盡一份綿薄之力。

是以為序。

世界太極拳冠軍　王二平

2021 年 3 月

Preface

Wushu origins from China - Belongs to the world

I am glad to hear that my student, Mr. Leng Xianfeng will publish the book "Chen-style taiji sword standard routine", and sincerely congratulate him. In fact, Mr. Leng Xianfeng followed me to learn various Tai Chi competition routines and traditional routines in the early 1990s. He was meticulous in his study and carefully worked out the details of each movement. He has been engaged in teaching of martial arts and Tai Chi for nearly 30 years. I particularly appreciate his conscientious hard working and perseverance. He is not only very attentive to the martial arts and Tai Chi career, but also very restrained, modest, and cautious. Even though he had been later introduced to Hong Kong by the Hong Kong SAR Government as " Excellent Talent Project '', he has been consulting me via the Internet about various technical and teaching difficulties and experiences. I have witnessed and experienced how he has steadily grown step by step.

He is relatively older among the many of my students, but he used to consult with his younger brothers and sisters as a younger brother. He has been particularly attentive to the various kinds of Chen style Taijiquan and kept learning while teaching for years. His accumulated knowledge and experience enable the completion this book "Chen-style taiji sword standard routine". It systematically elaborates every movement in aspects of transformations of Yin-Yang, emptiness-solidity, body-shifting, eye-looking and positions, etc. There are full of Illustrations in the book. The descriptions in it are easy to understand. It is suitable for both amateurs and beginners as basic tutorial. The important is that it is also translated into English which is the gospel of foreign friends learning Tai Chi.

The inheritance, development and innovation of Chinese martial arts are inseparable from the unremitting efforts of the authorities of national Wushu as well as many Wushu' co-workers.Not only It belongs to our Nation but also to the world. I hope that the publication of this book will make some contributions to accelerate the Wushu entering the Olympic Games, enhance the exchange of Wushu in various countries, and contribute to the popularization and improvement of Tai Chi.

World Taijiquan Champion
Erping Wang
MAR 2021

冷先鋒簡介

江西修水人，香港世界武術大賽發起人，當代太極拳名家、全國武術太極拳冠軍、香港全港公開太極拳錦標賽冠軍、香港優秀人才，現代體育經紀人，自幼習武，師從太極拳發源地中國河南省陳家溝第十代正宗傳人、國家非物質文化遺產傳承人、國際太極拳大師陳世通大師，以及中國國家武術隊總教練、太極王子、世界太極拳冠軍王二平大師。

中國武術段位六段、國家武術套路、散打裁判員、高級教練員，國家武術段位指導員、考評員，擅長陳式、楊式、吳式、武式、孫式太極拳和太極劍、太極推手等。在參加國際、國內大型的武術比賽中獲得金牌三十多枚，其學生弟子也在各項比賽中獲得金牌四百多枚，弟子遍及世界各地。

二零零八年被香港特區政府作為"香港優秀人才"引進香港，事蹟已編入《中國太極名人詞典》、《精武百傑》、《深圳名人錄》、《香港優秀人才》；《深圳特區報》、《東方日報》、《都市日報》、《頭條日報》、《文彙報》、《香港01》、《星島日報》、《印尼千島日報》、《國際日報》、《SOUTH METRO》、《明報週刊》、《星洲日報》、《馬來西亞大馬日報》等多次報導；《中央電視臺》、《深圳電視臺》、《廣東電視臺》、《香港無線 TVB 翡翠臺》、《日本電視臺》、《香港電臺》、《香港商臺》、《香港新城財經臺》多家媒體電視爭相報導，並被美國、英國、新加坡、馬來西亞、澳大利亞、日本、印尼等國際幾十家團體機構聘為榮譽顧問、總教練。

冷先鋒老師出版發行了一系列傳統和競賽套路中英文 DVD 教學片，最新《八法五步》、《陳式太極拳》、《長拳》、《五步拳》、《陳式太極劍》、《陳式太

極扇》、《太極刀》、《健身氣功八段錦》、《五禽戲》等中英文教材書，長期從事專業的武術太極拳教學，旨在推廣中國傳統武術文化，讓武術太極拳在全世界發揚光大。

　　冷先鋒老師本著"天下武林一家親＂的理念，以弘揚中華優秀文化為宗旨，讓中國太極拳成為世界體育運動為願景，以向世界傳播中國傳統文化為使命，搭建一個集文化、健康與愛為一體的世界武術合作共贏平臺，以平臺模式運營，走產融結合模式，創太極文化產業標杆為使命，讓世界各國武術組織共同積極參與，達到在傳承中創新、在創新中共享、在共用中發揚。為此，冷先鋒老師於 2018 年發起舉辦香港世界武術大賽，至今已成功舉辦兩屆，盛況空前。

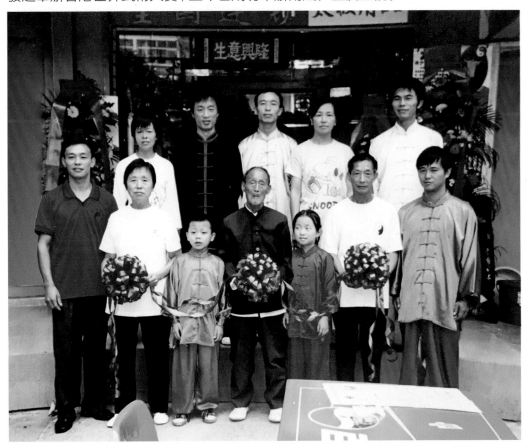

太極世家　　四代同堂

Profile of Master Leng Xianfeng

Originally from Xiushui, Jiangxi province, Master Leng is the promoter of the Hong Kong World Martial Arts Competition, a renowned contemporary master of taijiquan, National Martial Arts Taijiquan Champion, Hong Kong Open Taijiquan Champion, and person of outstanding talent in Hong Kong. A modern sports agent, Master Leng has been a student of martial arts since childhood, he is a 11th generation direct descendant in the lineage of Chenjiagou, Henan province – the home of taijiquan, and inheritor and transmitter of Intangible National Cultural Heritage. Master Leng is a student of International Taiji Master Chen Shitong and Taiji Prince, Master Wang Erping, head coach of the Chinese National Martial Arts Team and World Taiji Champion.

Master Leng, level six in the Chinese Wushu Duanwei System, is a referee, senior coach and examiner at national level. Master Leng is accomplished in Chen, Yang, Wu, Wu Hao and Sun styles of taijiquan and taiji sword and push-hands techniques. Master Leng has participated in a series of international and prominent domestic taijiquan competitions in taiji sword. Master Leng has won more than 30 championships and gold medals, and his students have won more than 400 gold medals and other awards in various team and individual competitions. Master Leng has followers throughout the world.

In 2008, Master Leng was acknowledged as a person of outstanding talent in Hong Kong . His deeds have been recorded in a variety of magazines and social media. Master Leng has been retained as

an honorary consultant and head coach by dozens of international organizations in the United States, Britain, Singapore, Malaysia, Australia, Japan, Indonesia and other countries.

Master Leng has published a series of tutorials for traditional competition routines on DVD and in books, the latest including "Eight methods and five steps", "Chen-style taijiquan", "Changquan", "Five-step Fist" and "Chen-style Taijijian","Chen-style Taijishan","Taijidao", "Health Qigong Baduanjin","Wuqinxi".Master Leng has long been engaged as a professional teacher of taijiquan, with the aim of promoting traditional Chinese martial arts to enable taijiquan to spread throughout the world.

Master Leng teaches in the spirit of "a world martial arts family", with the goal of "spreading Chinese traditional culture, and achieving a world-wide family of taijiquan." He promotes China's outstanding culture with the vision of "making taijiquan a popular sport throughout the world". As such, Master Leng has set out to to build an international business platform that promotes culture, health and love across the world of martial arts practitioners to achieve mutual cooperation and integrated production and so set a benchmark for the taiji culture industry. Let martial arts organizations throughout the world participate actively, achieve innovation in heritage, share in innovation, and promote in sharing! To this end, Master Leng initiated the Hong Kong World Martial Arts Competition in 2018 and has so far successfully held two events, with unprecedented grandeur.

 # 冷先鋒太極（武術）館

中華武術

火熱招生中……

地址：深圳市羅湖區紅嶺中路1048號東方商業廣場一樓、三樓
電話：13143449091　　13352912626

【名家薈萃】

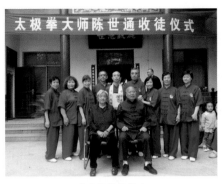

陳世通收徒儀式

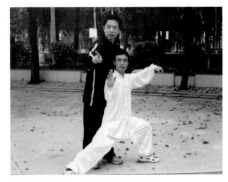

王二平老師

趙海鑫、張梅瑛老師

武打明星梁小龍老師

王西安老師

陳正雷老師

余功保老師

林秋萍老師

門惠豐老師

張山老師

高佳敏老師

蘇韌峰老師

李德印教授

錢源澤老師

張志俊老師

曾乃梁老師

郭良老師

陳照森老師

張龍老師

陳軍團老師

【名家薈萃】

劉敬儒老師

白文祥老師

張大勇老師

陳小旺老師

李俊峰老師

戈春艷老師

李德印教授

馬春喜、劉善民老師

丁杰老師

付清泉老師

馬虹老師

李文欽老師

朱天才老師

李傑主席

陳道雲老師

馮秀芳老師

陳思坦老師

趙長軍老師

【獲獎榮譽】

【電視采訪】

【電視采訪】

【電臺訪問】

【合作加盟】

【媒體報道】

【培訓瞬間】

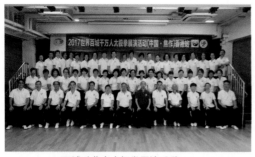

百城千萬人太極拳展演活動

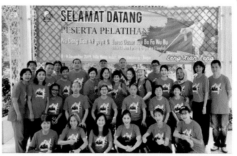

雅加達培訓

汕頭培訓

王二平深圳培訓

師父70大壽

香港公開大學培訓

印度尼西亞培訓

松崗培訓

香港荃灣培訓

王二平深圳培訓

陳軍團香港講學

印尼泗水培訓

油天培訓

印尼扇培訓

七星灣培訓

陳軍團香港講學培訓

油天培訓

美國學生

馬春喜香港培訓班

【賽事舉辦】

首屆世界太極拳交流大會

第二屆"太極羊杯"香港世界武術大賽

第二屆"太極羊杯"大賽

日本德島國際太極拳交流大會

首屆世界太極拳交流大會

馬來西亞武術大賽

東莞擂臺表演賽

首屆永城市太極拳邀請賽

首屆永城市太極拳邀請賽

2018首屆香港太極錦標賽

2019首屆永城市太極拳邀請賽

【專賣店】

目　錄
DIRECTORY

（一）起勢
1.Opening form

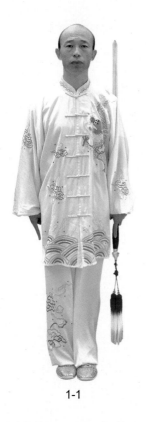

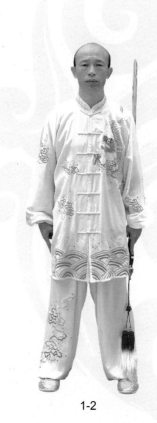

1-1 1-2

1 身體自然直立，兩手鬆垂輕貼大腿外側，左手持劍，右手握劍指，目視正前方（圖1-1）；

a. Body naturally upright, arms relaxed with palms resting lightly on outside of thighs, hold sword in left hand, form sword with fingers of right hand, look straight ahead (Figure 1-1);

2 左腳向左橫開一步，與肩同寬，目視前方（圖1-2）；

b. Move left foot one step to the left, shoulder width apart, look ahead (Figure 1-2);

（一）起勢
1.Opening form

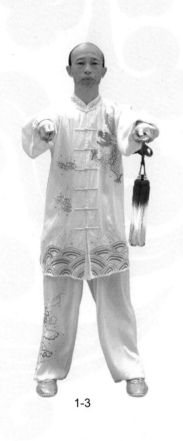

1-3

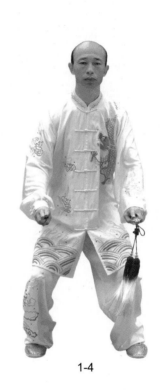

1-4

3 兩臂向前、向上慢慢平舉，與肩同高，目視前方（圖1-3）；

c. Slowly raise arms forwards and upwards to shoulder height, look ahead (Figure 1-3);

4 屈膝鬆胯，兩手屈肘下按至腹前，目視前下方（圖1-4）。

d. Bend knees and relax hips, bend elbows and press down to front of belly, look ahead and downwards (Figure 1-4).

（二）懶紮衣

2.Fasten coat

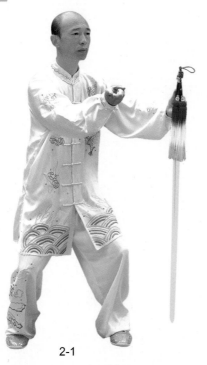

2-1

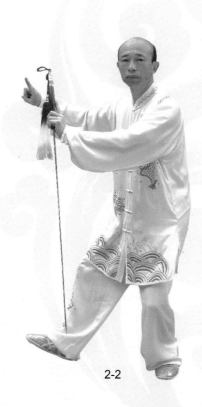

2-2

1 身體左轉，重心微偏右，兩手向左掤出，手心朝外，與肩同高，目視左前方（圖 2-1）；

a. Turn body left, weight slightly right, lift arms out to the left, palms facing out, shoulder height, look to the left and forwards (Figure 2-1);

2 身體右轉，重心左移，兩臂螺旋向右平捋，同時右腳尖外擺，目視兩手方向（圖 2-2）；

c. Turn body right, shift weight left, arms spiral and pull level to the right, at the same time swing right toes outwards, look in direction of the hands (Figure 2.2);

（二）懶紮衣

2.Fasten coat

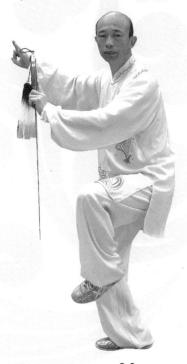

2-3

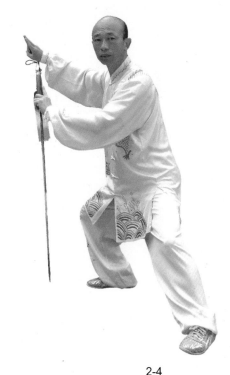

2-4

3 身體左轉，重心右移，提左腳，目視左前方向（圖 2-3）；

c. Turn body left, shift weight right, lift left foot, look left and forwards (Figure 2-3);

4 左腳向左前方擦出，同時兩手向右後方平推，目視左腳方向（圖 2-4）；

d. Slide left foot out to the front and left, at the same time push palms level to the right and rear, look in direction of left foot (Figure 2-4);

2

（二）懶紮衣

2.Fasten coat

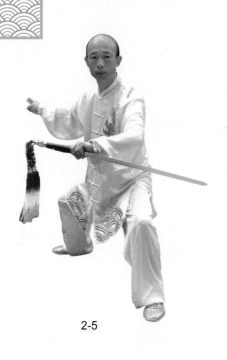

2-5

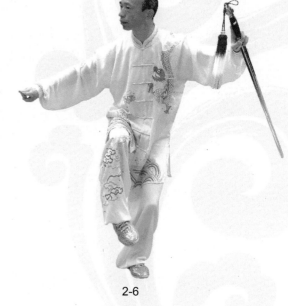

2-6

5 身體左轉，重心左移，兩手劃弧在胸前相合，右腳經左腳內側向右擦出，目視右腳方向（圖2-5；2-6；2-7）；

e. Turn body left, shift weight left, draw arc with both hands to front of chest, slide right foot from inside of left foot to the right, look in direction of the right foot (Figure 2-5; 2-6; 2-7);

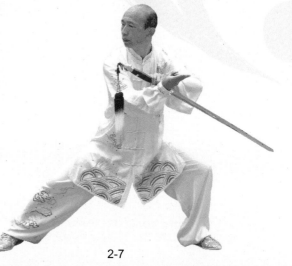

2-7

（二）懶紮衣

2.Fasten coat

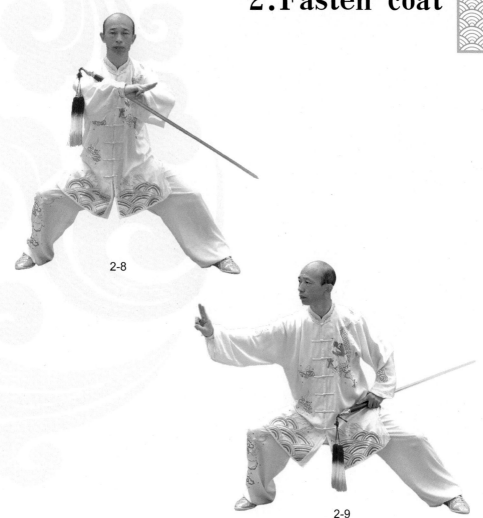

2-8

2-9

6 身體右轉，重心右移，兩手逆時針旋轉，右手橫拉至右膝上方，左手持劍收至左腰側，目視右手方向（圖2-8；2-9）。

f. Turn body right, shift weight right, hands whirl counterclockwise, draw right hand horizontally above right knee, draw sword in left hand beside left waist, look in direction of right hand (Figure 2-8; 2-9).

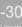

（三）護膝劍

3.Protect knee with sword

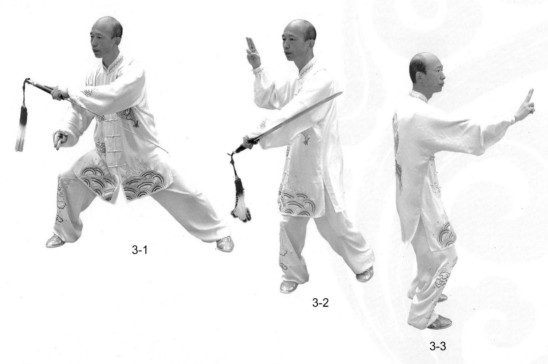

3-1

3-2

3-3

1 身體右轉，左手持劍向右前推，右手回收至左手下側，目視左手方向 (圖 3-1)；

a. Turn body right, push sword in left hand right and forwards, draw right hand below left hand, look in direction of left hand (Figure 3-1);

2 身體左轉，右腳向右後方撤步，右手劃弧經右耳側向前推出，左手持劍劃弧收至左腰側，目視右手方向 (圖 3-2；3-3)；

b. Turn body left, (draw left foot back to the left and rear,) draw right hand in an arc beside right ear and push out to front, draw sword in left hand in an arc beside left waist, look in direction of right hand (Figure 3-2; 3-3);

（三）護膝劍
3.Protect knee with sword

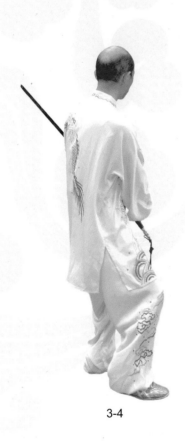
3-4

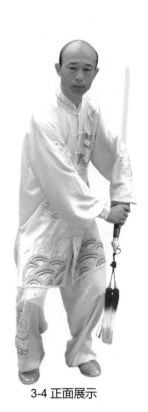
3-4 正面展示

3 身體左轉，右手劃弧至左手持劍位置，準備接劍，目視兩手方向（圖3-4、3-4a）；

c. Turn body left, bring right hand in arc to sword in left hand, ready to take sword, look in direction of hands (Figure 3-4, 3.4a);

3

（三）護膝劍

3.Protect knee with sword

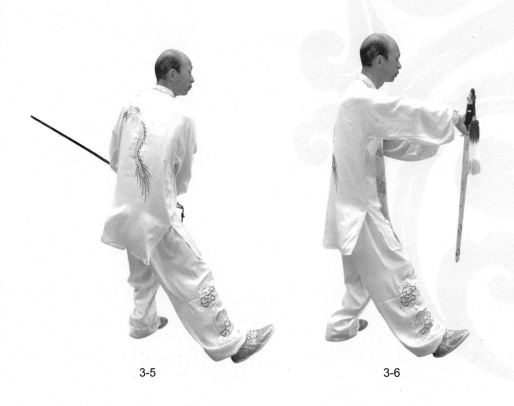

3-5 3-6

4 右手持劍，同時右腳向右前方上步，右手持劍向前撩劍，（圖 3-5、
3-6）；

d. Take sword in right hand, at the same time step right foot right and forwards, flick sword in right hand forwards (Figure 3-5; 3-6);

（三）護膝劍
3.Protect knee with sword

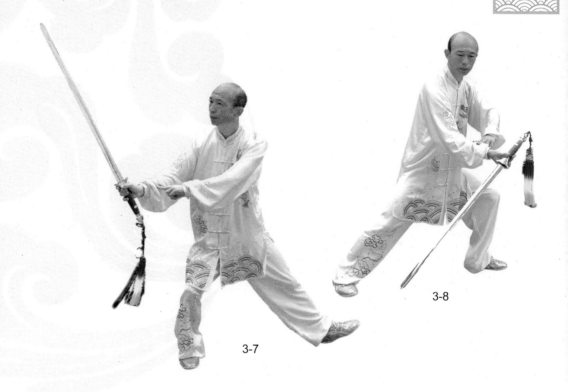

3-8

3-7

5 身體右轉，左腳向左前方上步，右手撩劍至右後方，目視劍的方向（圖3-7）；

e. Turn body right, step left foot left and forwards, with sword in right hand flick sword to right and rear, look in direction of sword (Figure 3-7);

6 身體左轉，右腳向右前方上步，右手撩劍至左前方，目視劍的方向（圖3-8；3-9）。

f. Turn body left, right foot step right and forwards, with right hand flick sword to left and forwards, look in direction of sword (Figure 3-8; 3-9);

（四）閉門式

4.Close doors

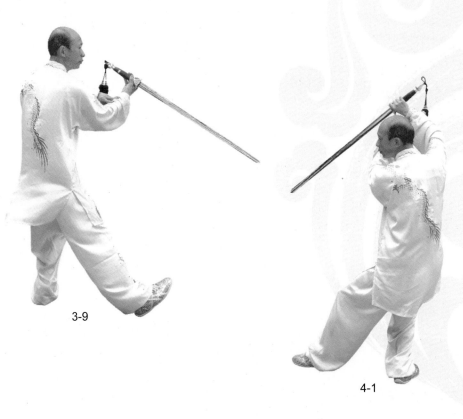

3-9

4-1

1 身體左轉，右腳內扣，左腳腳尖點地成虛步，同時右手內旋撩劍劃弧至右額上方，劍尖斜向下，目視劍尖方向（圖 4-1）；

a. Turn body left, twist right foot inwards, rest left foot on tips of toes and adopt empty stance, at the same time rotate sword in right hand inwards and draw arc to upper right of forehead, with sword tip obliquely downward, look in direction of sword tip (Figure 4-1).

（五）青龍出水

5. Green Dragon Emerges from the Water

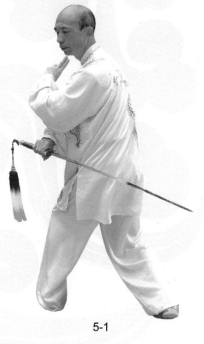

5-1

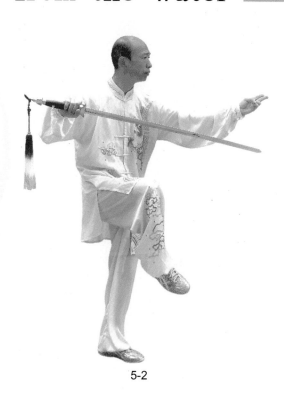

5-2

1 身體左轉，重心左移，右手持劍向左與右手相合，目視劍尖（圖 5-1）；

a. Turn body left, shift weight left, bring sword in right hand to left facing left hand, look in direction of sword tip (Figure 5-1);

2 身體右轉，提右腳向右轉 180 度，右手持劍與肩同高，左手劍指在左肩前，目視左手方向（圖 5-2）；

b. Turn body right, lift right foot and turn to the right 180 degrees, sword in right hand at shoulder level, left hand forming sword to front of left shoulder, look in direction of left hand (Figure 5-2);

（五）青龍出水

5.Green Dragon Emerges from the Water

3 右腳下震，同時左腳向左前擦出，右手持劍收至右腰間，左手劍指在胸前，目視左手方向（圖5-3）；

c. Drop right foot with a thud, at the same time slide left foot out to front and left, draw sword in right hand to right waist, draw left hand forming sword to front of chest (Figure 5-3);

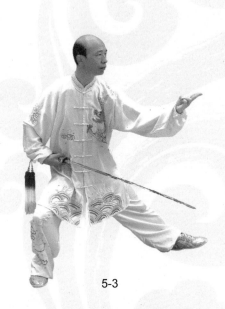

5-3

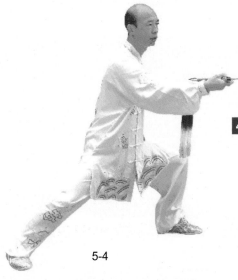

5-4

4 身體左轉，重心左移，右手持劍向前發力前刺，同時左手收至左腰間，目視劍的方向（圖5-4）；

d. Turn body left, shift weight left, stab forwards with sword in right hand, at the same time draw left hand to left waist, look in direction of sword (Figure 5-4);

（五）青龍出水
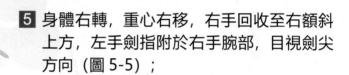

5. Green Dragon Emerges from the Water

5 身體右轉，重心右移，右手回收至右額斜上方，左手劍指附於右手腕部，目視劍尖方向（圖 5-5）；

e. Turn body right, shift weight right, draw right hand diagonally to upper right of forehead, left hand forming sword on right wrist, look in direction of sword tip (Figure 5-5);

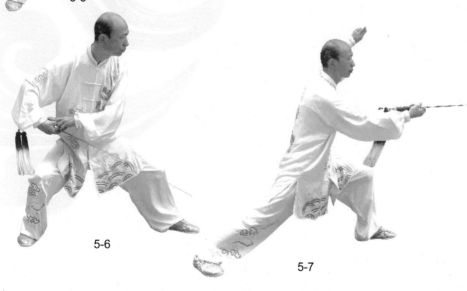

5-5

5-6

5-7

6 身體左轉，重心左移，右手持劍向前方直刺，左手劃弧至左額斜上方。目視劍尖方向（圖 5-6、5-7）。

f. Turn body left, shift weight left, pierce forwards with sword in right hand, draw left hand in an arc to upper left of forehead, look in direction of sword tip (Figure 5-6, 5-7).

5

（六）流星趕月

6.Shooting star overtakes the moon

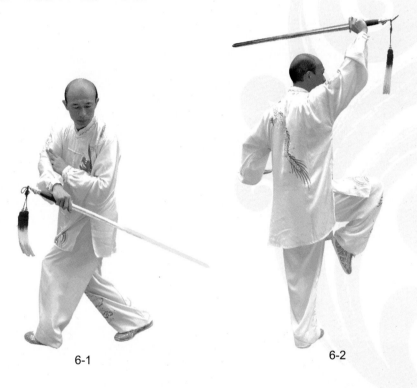

6-1

6-2

1 身體右轉，右手持劍逆時針旋轉，左腳向右腳後扣腳落步，目視劍的方向（圖6-1）；

a. Turn body right, rotate sword in right hand counterclockwise, pull left foot behind right foot and drop foot, look in direction of sword (Figure 6-1);

2 身體右轉，提右腳，右手持劍上舉，左手收至左胯旁，目視前方（圖6-2）；

b. Turn body right, lift right foot, raise sword in right hand, draw left hand beside left waist, look ahead (Figure 6-2);

（六）流星趕月

6. Shooting star overtakes the moon

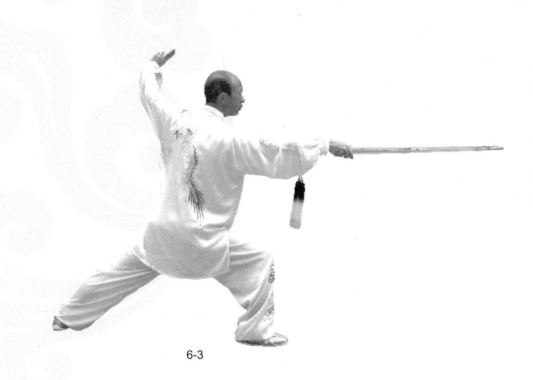

6-3

3 右腳向前下落成弓步，右手持劍向下劈劍，左手劃弧至左額斜上方，目視劍的方向（圖6-3）。

c. Drop right foot to front and adopt bow stance, slice downwards with sword in right hand, draw left hand in arc to upper left of forehead, look in direction of sword (Figure 6-3).

7 （七）展翅點頭

7.Spread wings and nod

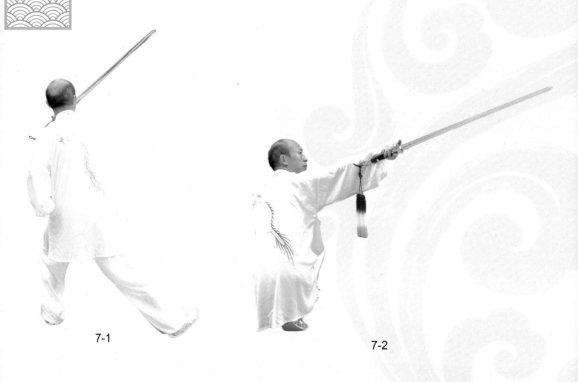

7-1　　　　　　　　　　7-2

1 身體左轉，右手持劍劃弧至左肩前，左手收至左腰側，目視劍的方向（圖 7-1）；

a. Turn body left, draw arc with sword in right hand to front of left shoulder, draw left hand to left waist, look in direction of sword (Figure 7-1);

2 身體右轉，右手持劍逆時針劃弧反撩劍，左手劃弧至左肩前，同時左腳向右腳後插步成歇步，目視劍尖方向（圖 7-2）；

b. Turn body right, draw counterclockwise arc with sword in right hand, draw arc with left hand to front of left shoulder, at the same time place left foot behind right foot and adopt rest stance, look in direction of sword tip (Picture 7-2);

（七）展翅點頭

7. Spread wings and nod

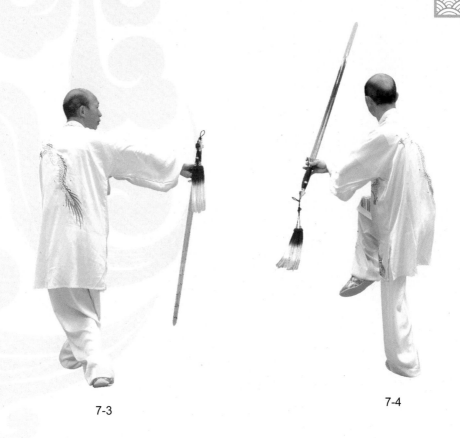

7-3

7-4

3 身體左轉，重心移至左腳，右手持劍順時針劃弧，左手劍指附於右手腕部，同時提右腳，目視劍的方向（圖 7-3；7-4）；

c. Turn body left, shift weight to left foot, draw clockwise arc with sword in right hand, left hand forming sword on right wrist, at the same time lift right foot, look in direction of sword (Figure 7-3; 7-4);

（七）展翅點頭

7.Spread wings and nod

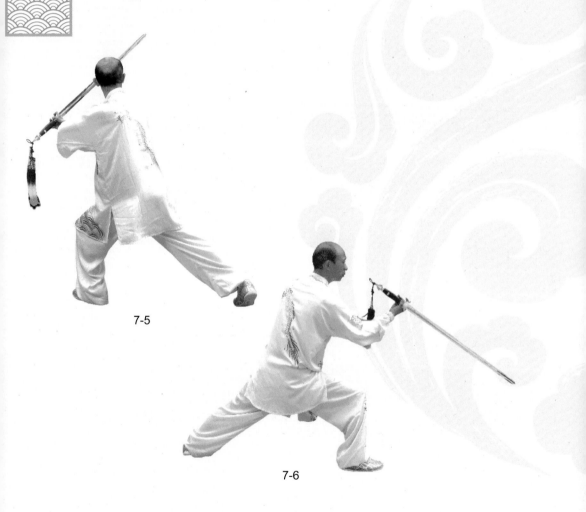

7-5

7-6

4 右腳向右後方撤步，左腳尖內扣，右腳尖外擺，右手持劍向右下方反手下刺，目視劍尖方向（圖 7-5；7-6）。

d. Draw right foot back to the rear and right, twist left toes inwards, swing right toes outwards, pierce backwards to lower right with sword in right hand, look in direction of sword tip (Figure 7-5; 7-6).

（八）撥草尋蛇

8.Pluck grass to find snake

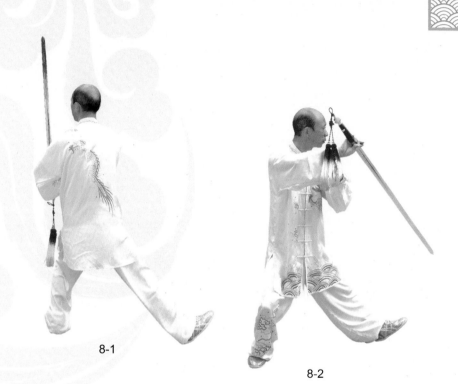

8-1

8-2

1 身體左轉，重心左移，右手持劍向左劃弧至左肩前，同時右腳尖上翹，目視劍的方向（圖 8-1）；

a. Turn body left, shift weight left, draw arc to left with sword in right hand, at the same time tilt right toes up, look in direction of sword (Figure 8-1);

2 身體右轉，重心右移，右手持劍劃弧至右肩前，同時右腳尖外擺，左腳向左前方上步，目視劍的方向（圖 8-2）；

b. Turn body right, shift weight right, draw arc with sword in right hand to front of right shoulder, at the same time swing right toes outwards, step left foot to the left and forwards, look in direction of sword (Picture 8-2);

8

（八）撥草尋蛇

8.Pluck grass to find snake

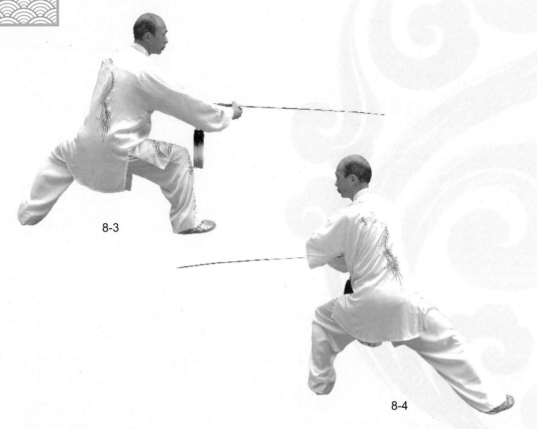

8-3

8-4

3 身體左轉，右腳上步成馬步，右手持劍向左平掃，目視劍的方向（圖 8-3）；

c. Turn body left, step right foot forward and adopt horse stance, sweep sword in right hand to the left, look in direction of sword (Figure 8-3);

4 身體繼續左轉，重心左移，右手持劍向左平掃至左膝前方，目視劍的方向（圖8-4）。

d. Continue turning left, shift weight left, sweep sword in right hand to front of left knee, look in direction of sword (Figure 8-4).

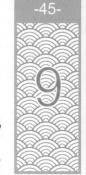

（九）金雞獨立

9.Golden Rooster Stands on one Leg

9-1

9-2

1 身體右轉，重心右移，右手持劍上舉，同時提左腳，目視劍尖方向（圖9-1）；

a. Turn body right, shift weight right, raise sword in right hand, at same time lift left foot, look in direction of sword tip (Figure 9-1);

2 身體右轉，左腳向左撤步，同時右手持劍向右劃弧，目視劍的方向（圖9-2）；

b. Turn body right, draw left foot back to the left, at the same time draw sword in right hand in an arc to the right, look in direction of sword (Picture 9-2);

（九）金雞獨立

9.Golden Rooster Stands on one Leg

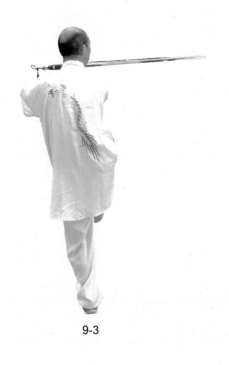

9-3

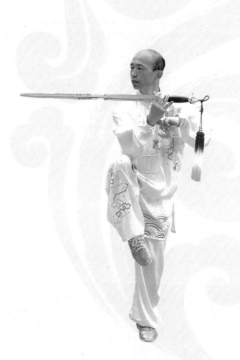

9-3a 正面示範

3 身體左轉，重心左移，右手持劍上舉，同時提右腳，目視劍尖方向（圖 9-3）。

c. Turn body left, shift weight left, raise sword in right hand, at the same time lift right foot, look in direction of sword tip (Picture 9-3).

（十）仙人指路

10.Immortals guide the way

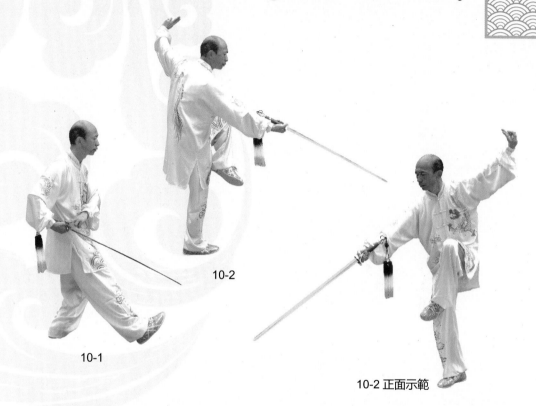

10-2

10-1

10-2 正面示範

1 身體右轉，右腳向右前下落，同時右手持劍收至右腰間，左手劍指附於右手腕部，目視前方（圖 10-1）；

a. Turn body right, drop right foot to right and forwards, at same time draw sword in right hand to right waist, left hand forming sword on right wrist, look ahead (Figure 10-1);

2 右手持劍向前下方刺出，左手劍指劃弧至左肩上方，同時提左膝，目視劍尖方向（圖 10-2）。

b. Stab forwards and downwards with sword in right hand, draw arc with left hand forming sword above left shoulder, at same time lift left knee, look in direction of sword tip (Figure 10-2).

（十一）古樹盤根

11. Ancient tree roots coiled

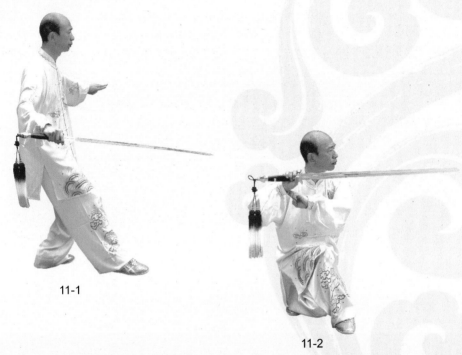

11-1

11-2

2 左腳向後撤步，同時兩手向兩側分開，有下壓之意，目視前方（圖11-1）；

a. Step left foot back, at the same time part hands (and jab elbows) to either side, with the intention of pressing down, look ahead (Figure 11-1).

3 身體右轉，兩腿交叉下蹲成歇步，同時右手持劍右轉至右肩前，左手劍指附於右手腕部，目視劍尖方向（圖11-2）。

c. Turn body right, cross your legs and squat into rest stance, at same time turn sword in right hand right in front of right shoulder, left hand forming sword on right wrist, look in direction of sword tip (Figure 11-2).

（十二）青龍擺尾

12.Green dragon wags tail

1 身體左轉，提左腳向前上步，右手持劍收至右腰間，目視前方（圖 12-1）；

a. Turn body left, lift left foot and step forward, draw sword in right hand to right waist, look ahead (Figure 12-1);

2 重心左移，右腳前蹬成左弓步，同時右手持劍向前刺出，左手劍指附於右手腕部，目視劍尖方向（圖 12-2）；

b. Shift weight left, thrust with right foot and adopt left bow stance, at the same time pierce forwards with sword in right hand, left hand forming sword on right wrist, look in direction of sword tip (Figure 12-2);

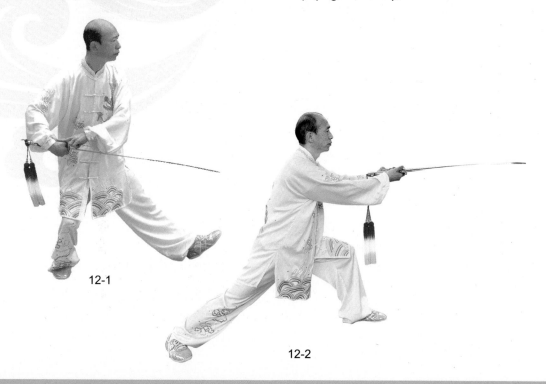

12-1

12-2

（十二）青龍擺尾

12. Green dragon wags tail

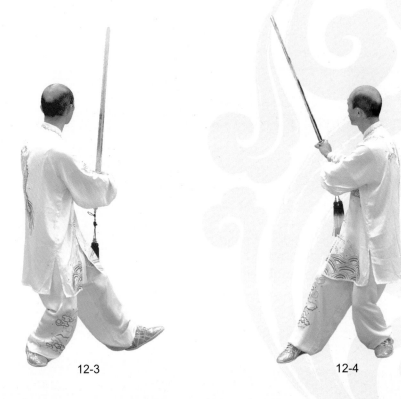

12-3　　　　　　　　　　　　12-4

3 身體左轉，重心右移，右手持劍向左劃弧至左肩前，左手劍指附於右手腕部，目視劍的方向（圖12-3）；

c. Turn body left, shift weight right, draw sword in right hand in an arc to front of left shoulder, left hand forming sword on right wrist, look in direction of sword (Figure 12-3);

4 身體右轉，重心左移，右手持劍劃弧至右肩前，左手劍指附於右手腕部，目視劍的方向（圖12-4）；

d. Turn body right, shift weight left, draw sword in right hand in arc to front of right shoulder, left hand forming sword on right wrist, look in direction of sword (Figure 12-4);

（十二）青龍擺尾

12. Green dragon wags tail

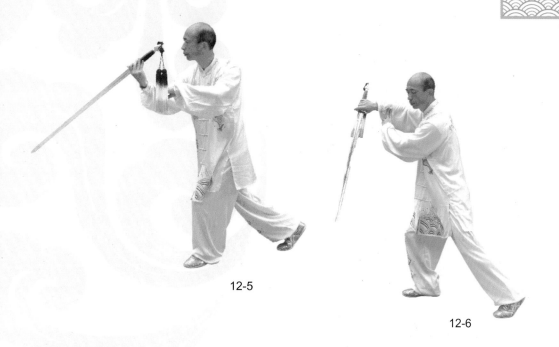

12-5

12-6

5 身體左轉，右腳向右後方撤步，同時右手持劍向左劃弧撩劍，左手劍指
附於右手腕部，目視劍的方向（圖 12-5）；

e. Turn body left, draw right foot back to the right and rear, at the same time draw sword in right hand in an arc to the left, left hand forming sword on right wrist, look in direction of sword (Figure 12-5);

6 重心右移，左腳向左後方撤步，同時右手持劍劃弧向右撩劍，左手劍指
附於右手腕部，目視劍的方向（圖 12-6）。

f. Shift weight right, draw left foot back to the left and rear, at the same time flick sword in right hand in an arc to the right, left hand forming sword on right wrist (left hand forming sword to front of left shoulder), look in direction of sword (Figure 12-6).

（十三）野馬跳澗
13. Wild horse jumps stream

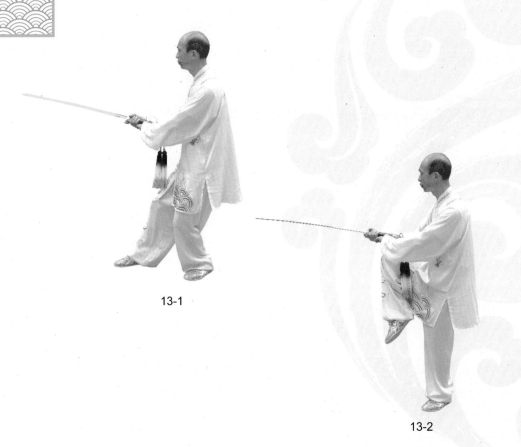

13-1

13-2

1 重心左移，右手持劍劃弧至兩手相合，同時提右腳，目視劍尖方向（圖 13-1；13-2）；

a. Shift weight left, draw an arc with sword in right hand to bring hands together, at the same time lift right foot, look in direction of sword tip (Figure 13-1; 13-2);

（十三）野馬跳澗

13. Wild horse jumps stream

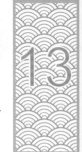

2 右腳向前下落，左腳蹬地向前騰空跳兩步，目視前方（圖13-3；13-4）；

b. Drop forward on right foot, thrust forward on left foot and jump forward two steps, look ahead (Picture 13-3; 13-4);

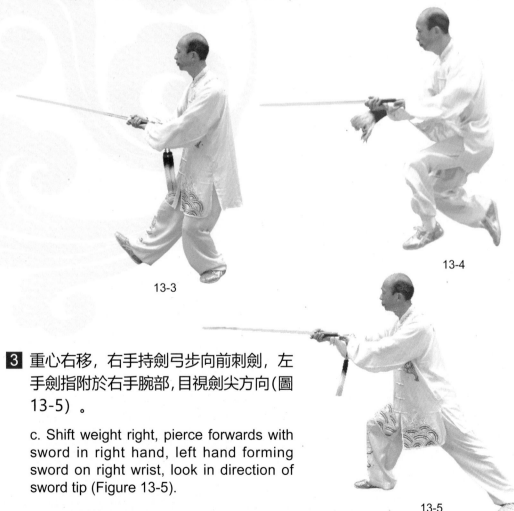

13-3

13-4

3 重心右移，右手持劍弓步向前刺劍，左手劍指附於右手腕部，目視劍尖方向（圖13-5）。

c. Shift weight right, pierce forwards with sword in right hand, left hand forming sword on right wrist, look in direction of sword tip (Figure 13-5).

13-5

14 （十四）白蛇吐信

14.White snake tempts

1 身體左轉，重心左移，右手持劍向左平掃，左手劍指附於右手腕部，目視劍的方向（圖 14-1）；

a. Turn body left, shift weight left, sweep sword in right hand to the left, left hand forming sword on right wrist, look in direction of sword (Figure 14-1);

2 重心右移，右腿下蹲成僕步，右手持劍回抽，與左腿平行方向，左手劍指附於右手腕部，目視劍尖方向（圖 14-2）；

b. Shift weight right, squat on right leg and adopt drop stance, draw sword in right hand back, parallel to left leg, left hand forming sword on right wrist, look in direction of sword tip (Figure 14-2);

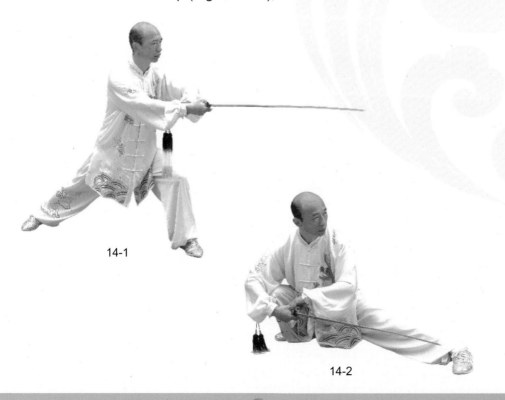

14-1

14-2

（十四）白蛇吐信

14. White snake tempts

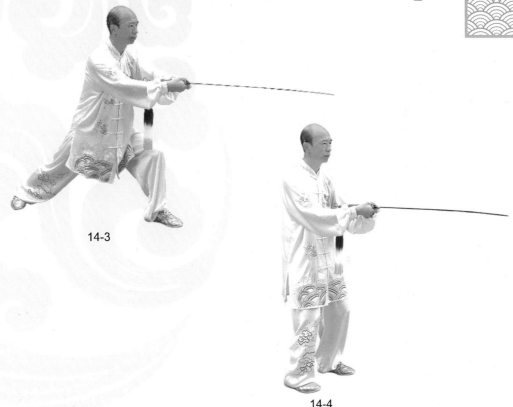

14-3

14-4

3 身體左轉，重心左移，左腿前蹬，右腿前弓，同時右手持劍向前刺劍，左手劍指附於右手腕部，目視劍尖方向（圖 14-3）；

c. Turn body left, shift weight left, pull forwards on left leg, bring right leg forwards, at the same time pierce forwards with sword in right hand, left hand forming sword on right wrist, look in direction of sword tip (Figure 14-3)

4 右腳收至左腳內側，右手持劍繼續向前平刺，左手劍指附於右手腕部，目視劍尖方向（圖 14-4）

d. Draw right foot to inside of left foot, continue to pierce forwards with sword in right hand, left hand forming sword on right wrist, look in direction of sword (Figure 14-4).

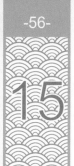

15

（十五）烏龍擺尾
15.Black dragon wags tail

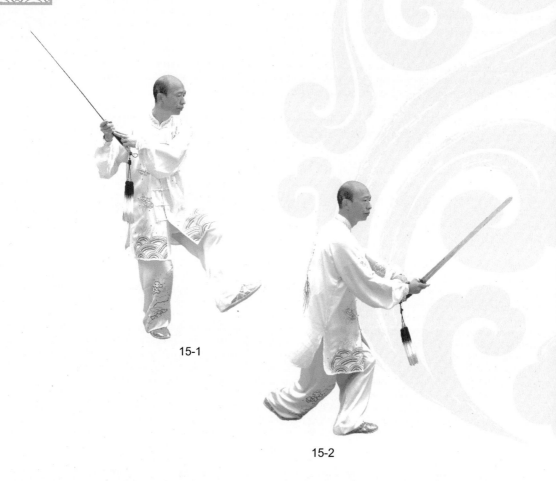

15-1

15-2

1 重心右移，提左腳向右前方上步，同時右手持劍向左向下劈劍，左手劍指附於右手腕部，目視劍的方向（圖 15-1；15-2）；

a. Shift weight right, lift left foot and step forward to the right, at the same time slice sword in right hand to the left, left hand forming sword on right wrist, look in direction of sword (Figure 15-1; 15-2);

（十五）烏龍擺尾
15.Black dragon wags tail

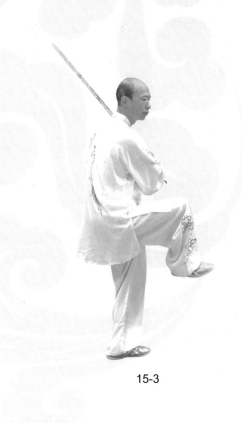

15-3

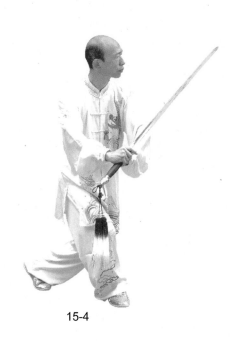

15-4

2 重心左移，提右腳向左前方上步，同時右手持劍向右向下劈劍，左手劍指附於右手腕部，目視劍的方向（圖15-3；15-4）。

b. Shift weight left, lift right foot and step forward to the left, at the same time slice sword in right hand to the right, left hand forming sword on right wrist, look in direction of sword (Figure 15-3; 15-4).

（十六）鍾馗仗劍
16. Zhong Kui wields sword

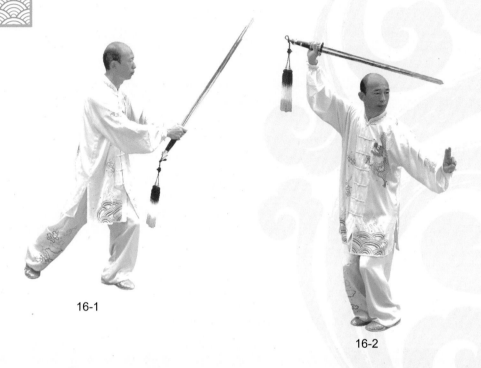

16-1

16-2

1 右腳向後撤步，右手持劍逆時針劃弧，左手劍指附於右手腕部，目視劍的方向（圖16-1）；

a. Step right foot back, draw counterclockwise arc with sword in right hand, left hand forming sword on right wrist, look in direction of sword (Figure 16-1);

2 重心右移，左腳收至右腳內側，同時右手持劍收至右額上方，左手劍指至劍尖下方，目視左手方向（圖16-2）。

b. Shift weight right, draw left foot to inside of right foot, at the same time strike sword in right hand to upper right of forehead, point left hand forming sword downwards, look in direction of left hand (Figure 16-2).

（十七）羅漢降龍

17.Luohan tames dragon

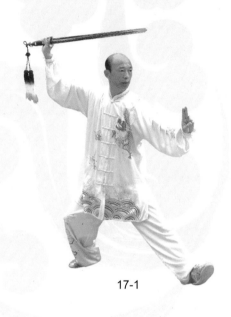

17-1

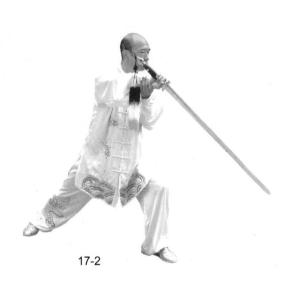

17-2

1 左腳向前上步，右手持劍微微向後回抽，目視左手方向（圖 17-1）；

a. Step forward with left foot, pull back slightly with sword in right hand, look in direction of left hand (Figure 17-1);

2 重心左移成弓步，右手持劍向前下方刺劍，左手附在右手腕部，目視劍尖方向（圖 17-2）。

b. Shift weight left and adopt bow stance, stab forwards and downwards with sword with in right hand, left hand forming sword on right wrist, look in direction of sword tip (Figure 17-2).

（十八）黑熊翻背
18.Black bear turns its back

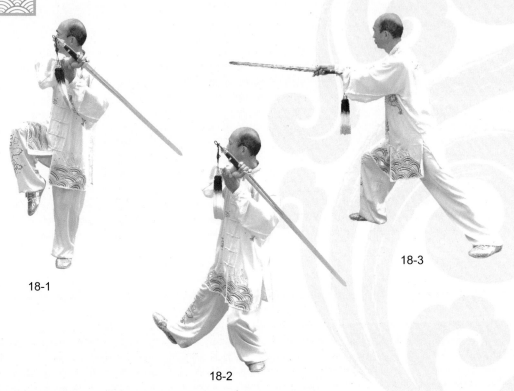

18-1

18-2

18-3

1 身體右轉，左腳內扣，提右腳，同時右手持劍收至左肩旁，左手劍指附於右手腕部，目視前方（圖 18-1）；

a. Turn body right, twist left foot inwards, lift right foot, at the same time bring sword in right hand to left shoulder, left hand forming sword on right wrist, look ahead (Figure 18-1);

2 身體繼續右轉，右腳向前上步，右手持劍劃弧向前劈劍，與肩同高，左手劍指附於右手腕部，目視劍尖方向（圖 18-2；18-3）。

b. Continue turning to the right, step forward with right foot, slice sword in right hand forward in an arc, shoulder height, left hand forming sword on right wrist, look in direction of sword tip (Figure 18-2; 18-3).

（十九）鷹熊鬥智

19.Eagle and bear battle of wits

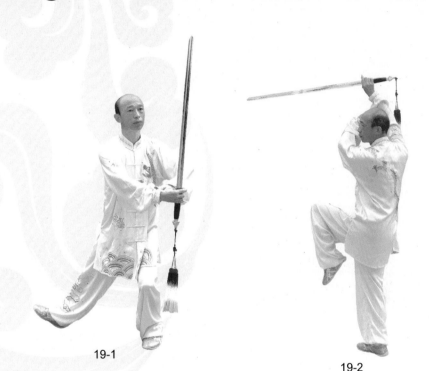

19-1

19-2

1 身體左轉，重心左移，右手持劍向劃弧至左肩旁，左手劍指附於右手腕部，目視劍的方向（圖 19-1）；

a. Turn body left, shift weight left, draw an arc with sword in right hand to left shoulder, left hand forming sword on right wrist, look in direction of sword (Figure 19-1);

2 身體右轉，重心右移，右手持劍向上舉架，左手劍指附於右手腕部，同時提右左腳，目視前方（圖 19-2）。

b. Turn body right, shift weight right, lift body with sword in right hand upwards, left hand forming sword on right wrist, at the same time lift left foot, look ahead (Figure 19-2).

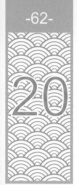

（二十）燕子啄泥

20.Swallows peck mud

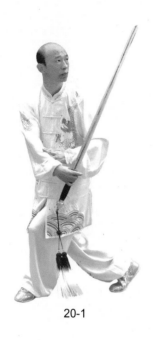

20-1

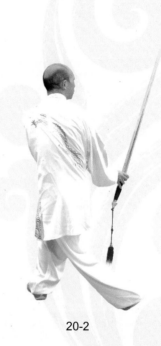

20-2

1 身體左轉，左腳下落，右手持劍向左後方掛劍，左手劍指附於右手腕部，目視劍的方向（圖 20-1）；

a. Turn body left, step forwards with left foot, lift sword in right hand to left and rear as if suspended, left hand forming sword on right wrist, look in direction of sword (Figure 20-1);

2 身體右轉，右腳上步，重心右移，右手持劍向右後方掛劍，左手劍指附於右手腕部，目視劍的方向（圖 20-2）；

b. Turn body right, step forwards with right foot, shift weight right, lift sword in right hand to the right and rear as if suspended, left hand forming sword on right wrist, look in direction of sword (Figure 20-2);

（二十）燕子啄泥

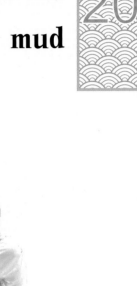

20.Swallows peck mud

20-3

20-4

3 左腳上步，右手持劍舉至右肩，左手劍指收至胸前，目視前方（圖20-3）；

c. Step left foot forwards, bring sword in right hand to right shoulder, draw left hand forming sword in front of chest, look ahead (Figure 20-3);

4 右腳上步成弓步，同時右手持劍向前下方點劍，左手劍指劃弧附於右手腕部，目視劍尖方向（圖20-4）。

d. Step forwards with right foot and adopt bow stance, at the same time point sword in right hand forwards and downwards, bring left hand forming sword in an arc onto right wrist, look in direction of sword tip (Figure 20-4).

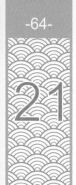

（二十一）翻花舞袖

21.Turn out flowers brandish sleeves

21-1

21-2

1 右腳向右後方撤步，右手持劍反腕，劍尖向右下方向，左手劍指附於右手腕部，目視劍尖方向（圖 21-1）；

a. Step right foot back to right and rear, reverse wrist with sword in right hand, point sword tip to right and rear, left hand forming sword on right wrist, look in direction of sword tip (Figure 21-1);

2 身體右轉，重心右移，左腳尖內扣，右腳尖外擺，成弓步刺劍，目視劍尖方向（圖 21-2）；

b. Turn body right, shift weight right, twist left toes inward, swing right toes outwards, adopt bow stance and pierce with sword, look in direction of sword tip (Figure 21-2);

（二十一）翻花舞袖

21. Turn out flowers brandish sleeves

3 右手持劍向左劃弧，左手劍指附於右手腕部，目視劍的方向（圖 21-3).c. Draw arc to left with sword in right hand, left hand forming sword on right wrist, look in direction of sword (Figure 21-3);

4 身體右轉再左轉，右手持劍逆時針劃弧至左肩旁，左手劍指附於右手腕部，同時提左腳，目視劍的方向（圖 21-4；21-5）；

d. Turn body right then left, draw sword in right hand in an arc counterclockwise to left shoulder, left hand forming sword on right wrist, at the same time lift left foot, look in direction of sword (Figure 21-4; 21-5);

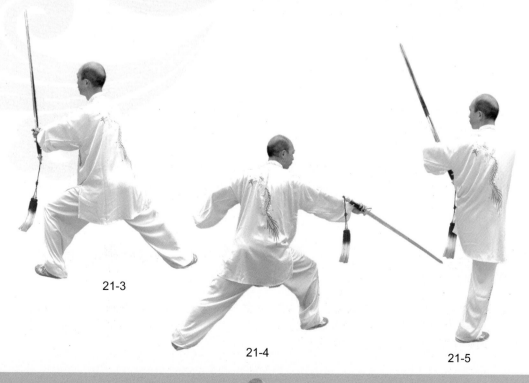

21-3

21-4

21-5

（二十一）翻花舞袖

21. Turn out flowers brandish sleeves

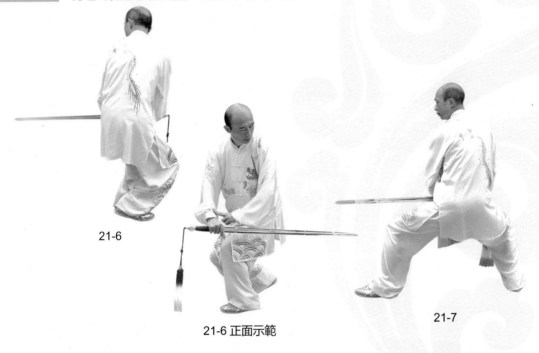

21-6

21-6 正面示範

21-7

5 左腳下震於右腳內側，同時身體下蹲，右手持劍下切，左手劍指附於右手腕部，目視劍的方向（圖 21-6）；

e. Thud left foot down on inside of right foot, at the same time squat down, slice down with sword in right hand, left hand forming sword on right wrist, look in direction of sword (Figure 21-6);

6 整個身體向後 180 度翻身跳，右腳先落地，右手持劍下劈，左手劍指附於右手腕部，目視劍尖方向（圖 21-7）。

f. Jump up and twist whole body around 180°, land on right foot first, slice down with sword in right hand, left hand forming sword on right wrist, look in direction of sword tip (Figure 21-7).

（二十二）海底撈月

22.Fetch moon from seabed

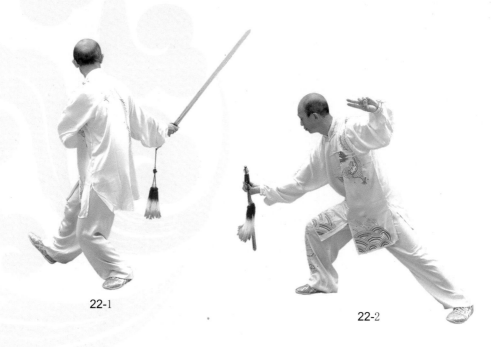

22-1

22-2

1 右腳上步，右手持劍向右後方劃弧，目視劍的方向（圖 22-1）；

a. Step forwards with right foot, draw sword in right hand in an arc to the right and rear, look in direction of sword (Figure 22-1);

2 身體左轉，右手持劍向右膝前下方撩劍，左手劍指劃弧至左肩上方，目視劍的方向（圖 22-2）；

b. Turn body left, draw sword in right hand to front of right knee, draw left hand forming sword in an arc to top of left shoulder, look in direction of sword (Figure 22-2);

22

（二十二）海底撈月

22.Fetch moon from seabed

3 身體左轉，右手持劍上提至左肩前，左手劍指附於右手腕部，同時提右腳，目視劍尖方向（圖 22-3）。

c. Turn body left, lift sword in right hand to the front of left shoulder, left hand forming sword on right wrist, at the same time lift right foot, look in direction of sword tip (Figure 22-3).

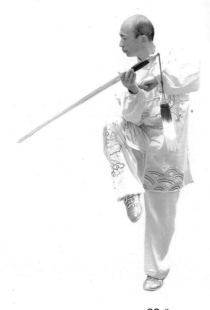

22-3

（二十三）仙人指路

23.Immortals guide the way

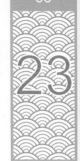

23-1

23-2

1 身體右轉，右腳向右前下落，同時右手持劍收至右腰間，左手劍指附於右手腕部，目視前方（圖 23-1）；

a. Turn body right, drop right foot to right and forwards, at same time draw sword in right hand to right waist, left hand forming sword on right wrist, look ahead (Figure 23-1);

2 右手持劍向前下方刺出，左手劍指劃弧至左肩上方，同時提左膝，目視劍尖方向（圖 23-2）。

b. Stab forwards and downwards with sword in right hand, draw arc with left hand forming sword above left shoulder, at same time lift left knee, look in direction of sword tip (Figure 23-2).

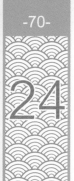

（二十四）鳳凰點頭

24.Phoenix nods its head

24-1 24-2

1 身體左轉，左腳下落，同時右手持劍內旋翻轉，左手下落至右肩前，目視劍的方向（圖 24-1）；

a. Turn body left, drop left foot, at the same time rotate sword in right hand inwards, drop left hand from front of right shoulder, look in direction of sword (Figure 24-1);

2 身體右轉，重心左移，右腳上步，腳尖點地成虛步，同時右手持劍向身後點劍，目視劍尖方向（圖 24-2）。

b. Turn body right, shift weight left, step forward with right foot, rest on tips of toes and adopt empty stance, at the same time flick sword in right hand behind you, look indirection of sword tip (Figure 24-2).

（二十五）蜻蜓點水

25.Dragonfly skimming the water

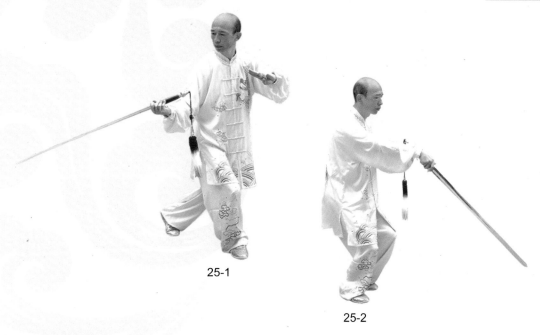

25-1

25-2

1 右腳踩實，兩腳向前連續上兩步，兩手分開，右手持劍逆時針劃弧，目視劍的方向（圖 25-1）；

a. Standing on right leg, take two steps forward, part hands, draw an arc counterclockwise with sword in right hand, look direction of the sword (Figure 25-1);

2 重心右移，左腳跟步至右腳後側，同時右手持劍向前點劍，左手劍指附於右手腕部，目視劍尖方向（圖 25-2）。

b. Shift weight right, bring left foot to rear of right foot, point sword in right hand forward, left hand forming sword on right wrist, look in direction of sword tip (Figure 25-2).

（二十六）斜飛式
26.Oblique flight form

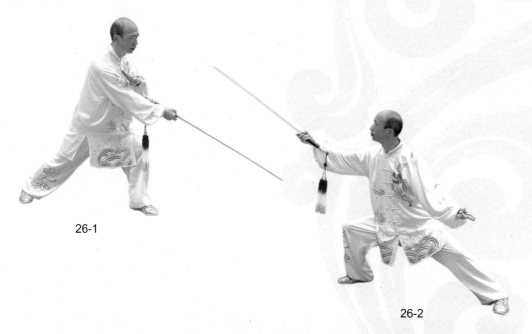

26-1

26-2

1 右腳向右後方撤步，右手持劍順時針劃弧，左手劍指順時針劃弧與右手相合，目視劍尖方向（圖 26-1）；

a. Draw right foot back to the right, draw sword in right hand in a clockwise arc, draw left hand forming sword in a clockwise arc and bring together with right hand, look in direction of sword tip (Figure 26-1);

2 身體右轉，重心右移，左腳尖內扣，右腳尖外擺，同時右手持劍向右斜分，左手外旋至左膝上方，目視劍尖方向（圖 26-2）。

b. Turn body right, shift weight right, twist left toes inwards, swing right toes outwards, at the same time lift sword in right hand diagonally to the right, rotate left hand to top of left knee, look in direction of sword tip (Figure 26-2).

（二十七）力托千斤

27

27.Lift one ton

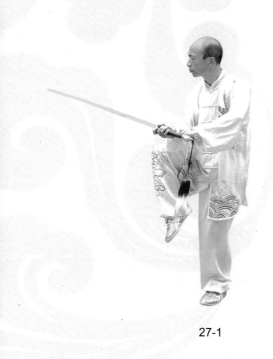

27-1

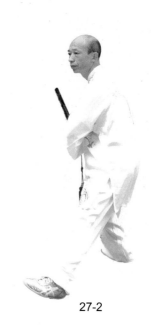

27-2

1 身體左轉，右手持劍劃弧上托，同時提起右腳，目視劍的方向（圖 27-1）；

a. Turn body left, draw sword in right hand in an arc and lift upwards, at the same time raise right foot, look in direction of sword (Figure 27-1);

2 右腳向左前方上步，然後左腳向左前方上步，右手持劍收至右腰間，左手劍指附於右手腕部，目視左前方（圖 27-2）；

b. Step right foot forwards to the left, then step left foot forwards to the left, bring sword in right hand to right waist, left hand forming sword on right wrist, look ahead to the left (Figure 27-2);

27 （二十七）力托千斤

27.Lift one ton

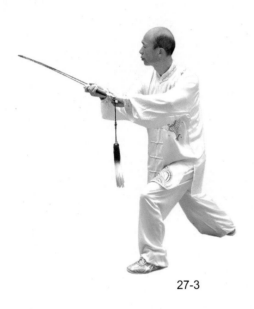

27-3

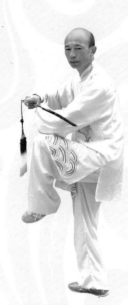

27-4

3 身體左轉，重心左移，右腳蹬地成弓步，同時右手持劍向左上托，左手劍指附於右手腕部，目視劍的方向（圖 27-3）；

c. Turn body left, shift weight left, thrust with right foot and adopt bow stance, at the same time strike sword in right hand upwards to the left, left hand forming sword on right wrist, look in direction of sword (Figure 27-3);

4 身體右轉，重心右移，右手內旋翻轉，同時提左腳，目視劍的方向（圖 27-4）；

d. Turn body right, shift weight right, flip right hand inwards, at the same time lift left foot, look in direction of sword (Figure 27-4);

（二十七）力托千斤

27. Lift one ton

5 左腳向右前方上步，然後右腳向右前方上步，右手持劍收至左腰間，左手劍指附於右手腕部，目視右前方（圖 27-5）；

e. Step left foot forwards to the right, then step right foot forwards to the right, bring sword in right hand to left waist, left hand forming sword on right wrist, look ahead to the right (Figure 27-5);

6 身體右轉，重心右移，左腳蹬地成弓步，同時右手持劍向右上托，左手劍指附於右手腕部，目視劍的方向（圖 27-6）。

f. Turn body right, shift weight right, thrust with left foot and adopt bow stance, at the same time strike sword in right hand upwards to the right, left hand forming sword on right wrist, look in direction of sword (Figure 27-6).

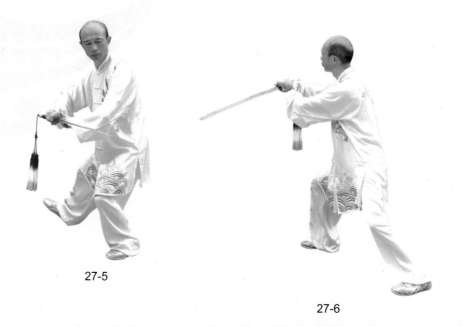

27-5

27-6

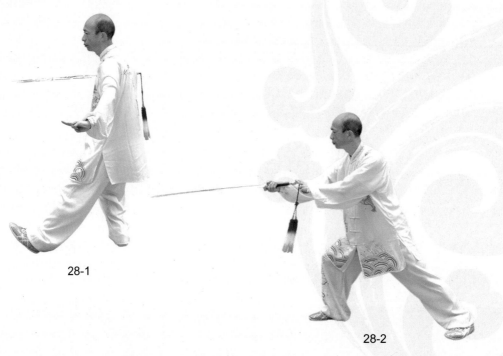

（二十八）哪吒探海

28. Ne Zha searches the sea

28-1

28-2

1 左腳上步，同時兩手分開，目視前方（圖28-1）；

a. Step left foot forwards, at the same time part hands, look ahead (Figure 28-1);

2 右腳上步，左腳前蹬成弓步，兩手劃弧相合向前下刺，目視劍尖方向（圖 28-2）。

b. Step right foot forwards, thrust with left foot and adopt bow stance, draw both hands in an arc and bring together to pierce forwards and downwards, look direction of the sword tip (Figure 28-2).

（二十九）白猿獻果

29. White ape offers fruit

29-1

29-2

1 重心左移，身體後仰，同時右手持劍經面前上舉，目視劍尖方向（圖 29-1）；

a. Shift weight left, lean back, at the same time lift right hand holding sword pommel upwards in front of face, look in direction of sword tip (Figure 29-1);

2 重心右移成弓步，同時兩手劃弧分開再相合，左手劍指附於右手腕部，目視劍尖方向（圖 29-2）。

b. Shift weight right and adopt bow stance, at the same time draw hands in an arc apart and back together, left hand forming sword on right wrist, look in direction of sword tip (Figure 29-2).

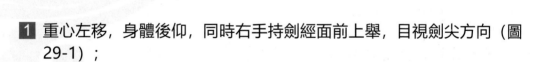

30

（三十）雙震驚雷

30.Double thunder clap

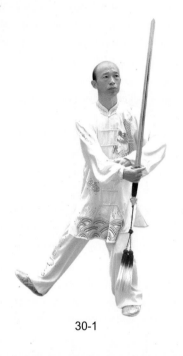

30-1

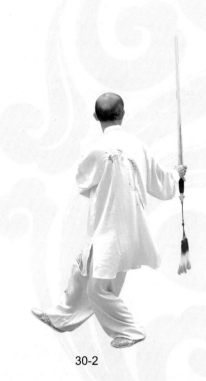

30-2

1 身體左轉，重心左移，右手持劍劃弧至左肩前，左手劍指附於右手腕部，目視劍的方向（圖 30-1）；

a. Turn body left, shift weight left, (step right foot back, at the same time) draw sword in right hand in an arc in front of the left shoulder, left hand forming sword on right wrist, look in direction of sword (Figure 30-1);

2 身體右轉，右手持劍劃弧向右至右肩側，目視劍的方向（圖 30-2）；

b. Turn body right,draw sword in right hand in an arc beside right shoulder, look in direction of sword (Figure 30-2);

（三十）雙震驚雷

30.Double thunder clap

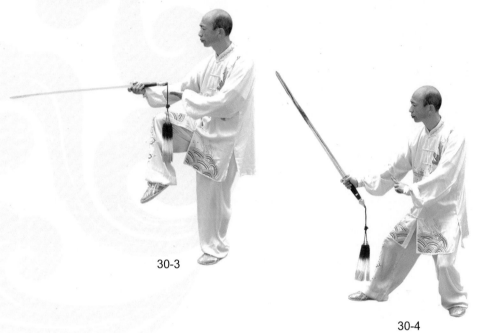

30-3

30-4

3 身體左轉，右手持劍劃弧向前與左手相合，同時提右腳，目視劍的方向（圖 30-3）；

c. Turn body left, draw sword in right hand in an arc forwards and bring left hand to meet it, at the same time draw right foot back, look in direction of sword (Figure 30-3);

4 左腳蹬地上跳再下震腳，同時右手持劍上托再下劈，左手劍指附於右手腕部，目視劍的方向（圖 30-4）。

d. Jump on left foot and then thud right foot, at the same time lift sword in right hand and then slice downwards, left hand forming sword on right wrist, look direction of the sword (Figure 30-4).

（三十一）劍似離弦

31.Sword snaps like bowstring

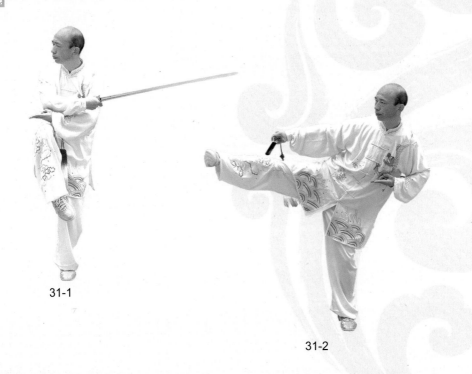

31-1

31-2

1 身體左轉，兩手相合，右手在上，同時提右腳，目視前方（圖 31-1）；

a. Turn body left, bring hands together, right hand above, at the same time lift right foot, looking ahead (Figure 31-1);

2 右腳向右側踹，同時右手持劍向右橫推，左手向後頂肘，目視踹腳方向（圖 31-2）；

b. Kick right foot to the right, at the same time cut horizontally with sword in right hand, jab left elbow backwards, look in direction of the kick (Figure 31-2);

（三十一）劍似離弦
31.Sword snaps like bowstring

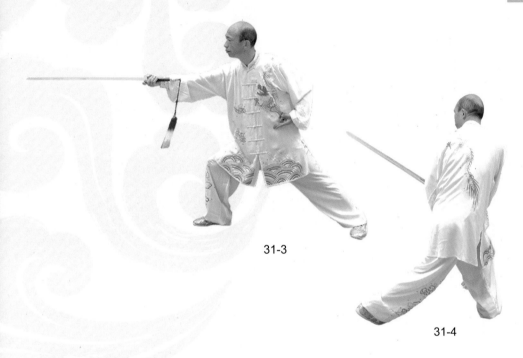

31-3

31-4

3 身體右轉，右腳向前上步成弓步，右手持劍向前直刺，左手劍指收至腰間，目視劍尖方向（圖 31-3）；

c. Turn body right, step right foot forwards and adopt bow stance, pierce forwards with sword in right hand, draw left hand forming sword to left waist, look in direction of sword tip (Figure 31-3);

4 右腳蹬地，身體右轉，向前叉步跳出，同時右手持劍逆時針劃弧一圈至身體的左側，左手劍指附於右手腕部，目視劍的方向（圖 31-4）。

d. Thrust with right foot, turn body right, jump forward into a fork stance, at the same time draw sword in your right hand in a circle counterclockwise on the left side of the body, look in direction of sword (Figure 31-4).

（三十二）摘星換鬥

32.Pluck star and switch around

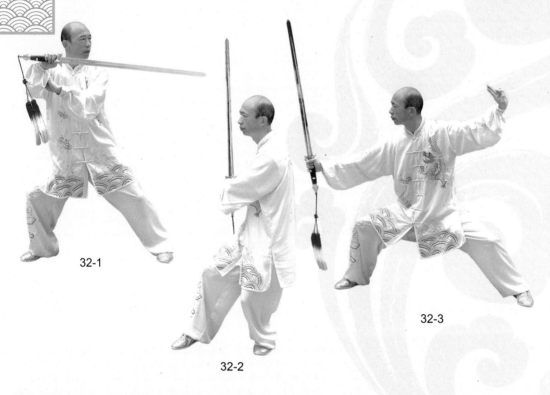

32-1

32-2

32-3

1 身體右轉，右手持劍劃弧經胸前收至右腰間，右腳回收腳尖點地成虛步，左手劍指附於右手腕部，目視前方（圖 32-1；32-2）；

a. Turn body right, draw sword in right hand in an arc to front of chest and draw back to right waist, withdraw right foot, rest on tips of the toes and adopt empty stance, left hand forming sword on right wrist, and look ahead (Figure 32-1; 32-2);

2 右腳向前上步，腳尖內扣，同時右手持劍向前馬步推劍，左手劍指劃弧收至左肩後側，目視劍的方向（圖 32-3）。

b. Step right foot forwards, twist toes inwards, at the same time punch sword in right hand forwards in a horse stance, draw left hand forming sword in an arc to rear of left shoulder, look in direction of sword (Figure 32-3).

（三十三）怪莽翻身

33.Surprise escape

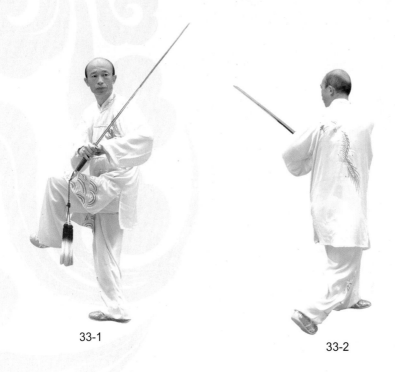

33-1

33-2

1 身體左轉，右手持劍劃弧收至左腰側，左手劍指附於右手腕部，同時提左膝，目視劍的方向（圖 33-1）；

a.Turn body left, draw sword in right hand in an arc to the left waist, left hand forming sword on right wrist, raise left knee, look in direction of sword (Figure 33-1);

2 身體右轉，左腳在右腳外側下落，腳尖內扣，然後提右腳，右手持劍在左腰側，目視右腳方向（圖 33-2；33-3）；

b. Turn body right, drop left foot on outside of right foot, twist toes inwards, then lift right foot, sword in right hand beside left waist, look in direction of right foot (Figure 33-2; 33-3);

（三十三）怪莽翻身

33.Surprise escape

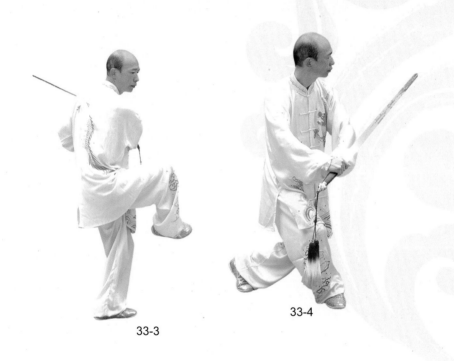

33-3

33-4

3 身體繼續右轉，右腳擺步下落，同時右手持劍向右下方劈劍，左手劍指附於右手腕部，目視劍的方向（圖 33-4）。

c. Continue turning right, swing round and lift and drop right foot, at the same time slice sword in right hand to the lower right, left hand forming sword on right wrist, look in direction of sword (Figure 33-4).

（三十四）餓虎撲食

34

34.Hungry tiger pounces

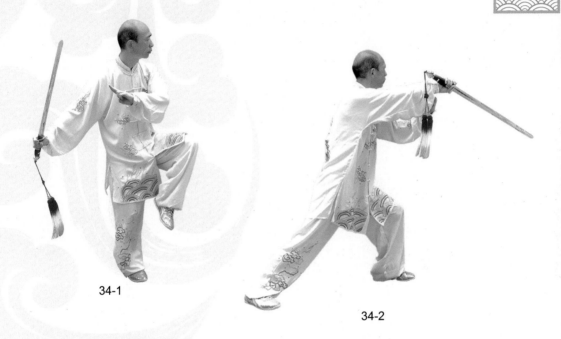

34-1

34-2

1 重心移至右腳，提左腳，同時右手持劍劃弧至右肩後側，左手劍指收至右肩前，目視左前方（圖 34-1）；

a. Shift weight onto right foot, lift left foot, at the same time draw sword in right hand in an arc to rear of right shoulder, draw left hand forming sword to front of right shoulder, look ahead and to the left (Figure 34-1);

2 左腳向左前上步，右手持劍向左前方反手下刺，左手劍指附於右手腕部，目視劍尖方向（圖 34-2）。

b. Step left foot forwards, pierce down to the left and forwards with sword in right hand reversed, left hand forming sword on right wrist, look in direction of sword tip (Figure 34-2).

（三十五）葉底藏花

35.Blossom hidden in leaves

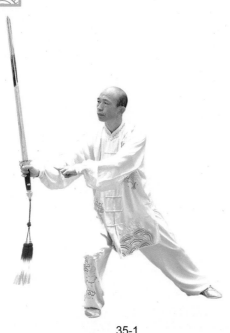

35-1

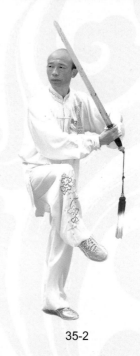

35-2

1 身體右轉，重心右移，右手持劍劃弧至右肩前，左手劍指附於右手腕部，目視劍的方向（圖 35-1）；

a.Turn body right, shift weight right, draw sword in right hand in an arc to front of right shoulder, left hand forming sword on right wrist, look in direction of sword (Figure 35-1);

2 身體左轉，重心左移，提右腳，同時右手持劍收至左肩前，左手劍指附於右手腕部，目視前方（圖 35-2）；

b.Turn body left, shift weight left, lift right foot, at the same time draw sword in right hand to front of left shoulder, left hand forming sword on right wrist, look ahead (Figure 35-2);

（三十五）葉底藏花

35.Blossom hidden in leaves

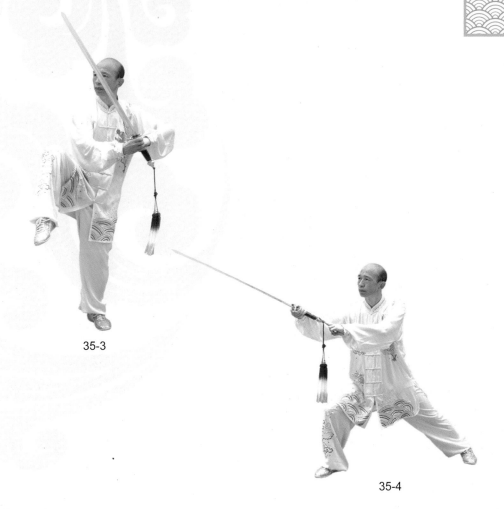

35-3

35-4

3 左腳蹬地向前上跳，右腳向右前方下落，右手持劍向前上方刺劍，左手劍指附於右手腕部，目視劍尖方向（圖 35-3；35-4）。

c. Hop on left foot, drop right foot to right and forwards, pierce forwards and upwards with sword in right hand, left hand forming sword on right wrist, look in direction of sword tip (Figure 35-3; 35-4).

（三十六）韋陀獻杵

36.Wei Tuo offers pestle

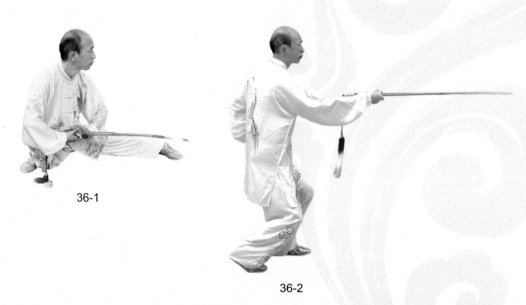

36-1

36-2

1 身體左轉，右手持劍向左回帶，僕步，左手劍指附於右手腕部，目視前方（圖36-1）；

a.Turn body left, draw sword in right hand back to the left, drop stance, left hand forming sword on right wrist, look ahead (Figure 36-1);

2 身體左轉，重心左移，右腳收至左腳的右後側，同時右手持劍向前平刺，左手劍指收至左腰側，目視劍尖方向（圖36-2）。

b. Turn body left, shift weight left, bring right foot to the right and rear of left foot, at the same time stab forwards with sword in right hand, draw left hand forming sword beside left waist, look in direction of sword tip (Figure 36-2).

（三十七）磨盤劍

37. Grinding sword

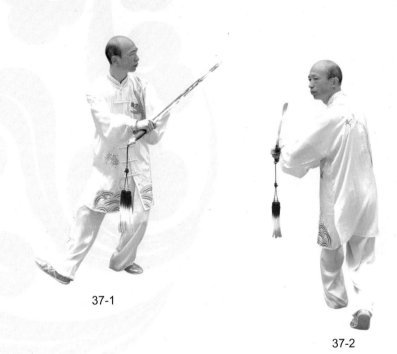

37-1

37-2

1 身體右轉，右腳向右擺腳下落，同時右手持劍內旋翻轉至左胸前，左手劍指附於右手腕部，目視劍的方向（圖37-1）；

a. Turn body right, swing around and lift and drop right foot, at the same time flip sword in right hand inwards to front of right chest, left hand forming sword on right wrist, look in direction of sword (Figure 37-1);

2 身體繼續右轉，左腳向後扣腳，目視劍的方向（圖37-2）；

b. Continue turning right, twist left foot to rear, look in direction of sword (Picture 37-2);

（三十七）磨盤劍

37.Grinding sword

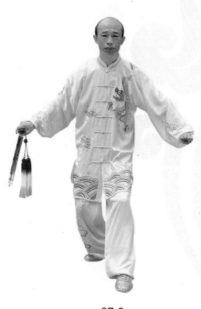

37-3

3 身體繼續右轉，右腳向後撤步，可以做一個小跳步，左腳微提起再腳尖點地成虛步，兩手分開至兩腰側，目視前方（圖 37-3）。

c. Continue turning right, step right foot backwards, may make a small jump step, lift left foot slightly, rest on tips of toes and adopt empty stance, part hands to either side of waist, look ahead (Figure 37-3).

（三十八）金針指南

38

38. Golden needle points south

38-1

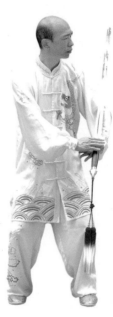

38-2

1 左腳向前上步，右腳緊跟上步，兩腳間距離與肩同寬，同時右手持劍向前平刺，左手劍指附於右手腕部，目視前方（圖 38-1）；

a. Step left foot forwards, followed by right foot, shoulder-width apart, at the same time pierce forwards with sword in the right hand, left hand forming sword on right wrist, look ahead (Figure 38-1));

2 身體左轉，右手持劍內旋翻轉交劍至左手，目視劍的方向（圖 38-2）；

b. Turn body left, flip sword in right hand inwards and pass to left hand, look in direction of sword (Figure 38-2);

38

（三十八）金針指南

38.Golden needle points south

38-3

38-4

3 兩手向後劃弧走立圓至前方，手心向下，與肩同高，目視前方（圖 38-3；38-4）。

c. Draw hands in an arc backwards and bring in a full circle to the front, palms down, shoulder height, look ahead (38-3; 38-4).

（三十九）收勢

39.Closing form

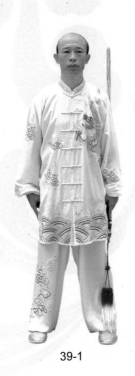

39-1

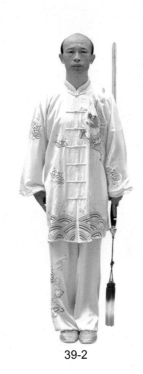

39-2

1 兩臂緩緩下落至兩胯旁，目視前方（圖 39-1）；

a. Slowly drop arms to beside hips, look ahead (Figure 39-1);

2 左腳收至右腳內側，並步還原（圖 39-2）。

b. Bring left foot to inside of right foot, parallel, rise and recompose (Figure 39-2).

【太極扇】

武術/廣場舞/表演扇

可訂制LOGO

紅色牡丹

粉色牡丹

黃色牡丹

紫色牡丹

黑色牡丹

藍色牡丹

綠色牡丹

黑色龍鳳

紅色武字

黑色武字

紅色龍鳳

金色龍鳳

純紅色

紅色冷字

紅色功夫扇

紅色太極

打開淘寶天貓APP
掃碼進店

微信掃一掃
進入小程序購買

【專業太極刀劍】

晨練/武術/表演/太極劍

打開淘寶天猫
掃碼進店

手工純銅太極劍　　神武合金太極劍　　桃木太極劍　　平板護手太極劍　　手工銅錢太極劍　　鏤空太極劍

手工純銅太極劍　　神武合金太極劍

劍袋·多種顏色、尺寸選擇

銀色八卦圖伸縮劍　　銀色花環圖伸縮劍

龍泉寶刀

棕色八卦圖伸縮劍　　紅棕色八卦圖伸縮劍

微信掃一掃
進入小程序購買

【學校學生鞋】

多種款式選擇・男女同款

可定制logo

香港及海外掃碼購買

檢測報告

商品注册證

打開淘寶天貓APP

掃碼進店

微信掃一掃

進入小程序購買

【武術/表演/比賽/專業太極鞋】

正紅色【升級款】
XF001 正紅

打開淘寶天貓
掃碼進店

微信掃一掃
進入小程序購買

藍色【經典款】
XF8008-2 藍

黃色【經典款】
XF8008-2 黃色

紫色【經典款】
XF8008-2 紫色

正紅色【經典款】
XF8008-2 正紅

黑色【經典款】
XF8008-2 黑

綠色【經典款】
XF8008-2 綠

桔紅色【經典款】
XF8008-2 桔紅

粉色【經典款】
XF8008-2 粉

XF2008B（太極圖）白

XF2008B（太極圖）黑

XF2008-2 白

XF2008-3 黑

5634 白

XF2008-2 黑

【太極羊 · 專業武術鞋】

兒童款 · 超纖皮

打開淘寶APP

掃碼進店

XF808-1 銀

XF808-1 白

XF808-1 紅

XF808-1 金

XF808-1 藍

XF808-1 黑

XF808-1 粉

長袖款

短袖款

微信掃一掃

進入小程序購買

 【專業太極服】

多種款式選擇 · 男女同款

微信掃一掃

進入小程序購買

黑白漸變仿綢

淺棕色牛奶絲

白色星光麻

亞麻淺粉中袖

白色星光麻

真絲綢藍白漸變

【正版教學光盤】

正版教學光盤 太極名師 冷先鋒 DVD包郵

香港國際武術總會裁判員、教練員培訓班
常年舉辦培訓

　　香港國際武術總會培訓中心是經過香港政府注册、香港國際武術總會認證的培訓部門。爲傳承中華傳統文化、促進武術運動的開展，加强裁判員、教練員隊伍建設，提高武術裁判員、教練員綜合水平，以進一步規範科學訓練爲目的，選拔、培養更多的作風硬、業務精、技術好的裁判員、教練員團隊。特開展常年培訓，報名人數每達到一定數量，即舉辦培訓班。

報名條件：熱愛武術運動，思想作風正派，敬業精神强，有較高的職業道德，男女不限。

培訓內容：1.規則培訓；2.裁判法；3.技術培訓。考核內容：1.理論、規則考試；2.技術考核；3.實際操作和實踐(安排實際比賽實習)。經考核合格者頒發結業證書。培訓考核優秀者，將會録入香港國際武術總會人才庫，有機會代表參加重大武術比賽，并提供宣傳、推廣平臺。

聯系方式

深圳：13143449091（微信同號）

　　　13352912626（微信同號）

香港：0085298500233（微信同號）

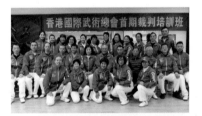

國際武術教練證

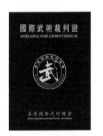
國際武術裁判證

微信掃一掃

進入小程序

香港國際武術總會第三期裁判、教練培訓班

打開淘寶APP

掃碼進店

【出版各種書籍】

申請書號>設計排版>印刷出品
>市場推廣
港澳台各大書店銷售

冷先鋒

《國際武術大講堂系列教學》之四
Second of the international wushu series lecture class
陳式太极拳老架一路
香港先鋒武術協會印

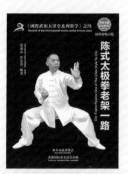

《國際武術大講堂系列教學》之三
The first set of international wushu competition routines
第一套國際武術競賽套路
長 拳
Changquan
冷先鋒 編著
Xianfeng Leng Author
香港國際武術總會出版
Hong Kong International Wushu Association

《國際武術大講堂系列教學》之二
樂齡養生太極拳
Health Preservation Taijiquan for the Elderly
冷先鋒 編著
Xianfeng Leng Author
香港先鋒武術集團 審定
中國香港老年人體育協會出版
China Hong Kong Eldery Sports Association

我的養生秘笈
國際老子養生研究會出版

陳式太極拳老架一路
OLD-FRAME ROUTINE OF THE CHEN TAIJIQUAN
《國際武術大講堂系列教學》之一
國台強 主編
香港國際武術出版社
HONG KONG INTERNATIONAL WUSHU PUBLISHING COMPANY

《國際健康太極系列套路》之一
One of the international health Tai Chi series section
健康太極十三勢
HEALTH TAI CHI 13
中華武術
許其成 冷先鋒 拍著
QISHENG XU XIANFENG LENG AUTHOR

蔡李佛
技擊法
黃羽帆 編著
CHOY LI FUT
FIGHTING TECHNIQUES
WONG YU-FAN

《陳式太極拳入門訓練攻略》
Chen style Taichi Training Series - Book 1
老架一路
入門 老架一路 老架二路 精功十三杆
梁志城 編著
Writed by / Simon Liang

陳式太极拳
競賽套路
分解教學(femore)

新編太极拳競賽套路
太极十三势
八法五步
TAI CHI
THIRTEEN
EIGHT METHODS
AND
FIVE STEPS
冷先鋒 鄧敏佳 編著
Xianfeng Leng Minjia Deng Author
香港國際武術總會 審定
Hong Kong International Wushu Association Accreditation
太极拳集委出版
Published by Taiji Kong Group

CHEN'S TAIJI BROADSWORD
AND PERSPECTIVES ON TAIJI QUAN
陳氏春秋大刀 和
太極拳觀
張陽陽 編著
Dayang Zhang Author
香港國際武術總會 審定
Hong Kong International Wushu Association Accreditation

《秘傳內功太極修煉須知》
及 陳式太極拳83式
王石泉著

禪武太極刀
Chinese Spine injury Science" series of books
李暉玲 編著
Sandy Li Author
香港國際武術總會出版
Hong Kong International Wushu Association

《國際武術大講堂系列教學》之一
校園武術規定教材
The school wushu Stipulate textbook
五步拳
Five Steps Fist
冷先鋒 編著
Xianfeng Leng Author
香港國際武術總會出版
Hong Kong International Wushu Association

陳家溝·正宗陳氏太極拳
陳世超 陳軍軍 編著
香港國際武術總會出版

新編太極拳競賽套路
HOW TO PRACTICE THE "EIGHT METHODS
AND FIVE STANCES" OF TAIJI
如何練好
太極八法五步
冷先鋒 鄧敏佳 編著
Xianfeng Leng Minjia Deng Author
香港國際武術總會出版 Hong Kong International Wushu Association

國際武術大講堂系列教程之一
《陳式太極劍規定套路》

香港先鋒國際集團　審定

太極羊集團　　贊助

香港國際武術總會有限公司　出版

香港聯合書刊物流有限公司　　發行

代理商：台灣白象文化事業有限公司

書號：ISBN 978-988-75078-0-2

香港地址：香港九龍彌敦道 525 -543 號寶寧大廈 C 座 412 室

電話：00852-95889723 \91267932

深圳地址：深圳市羅湖區紅嶺中路 2018 號建設集團大廈 B 座 20A

電話：0755-25950376\13352912626

台灣地址：401 台中市東區和平街 228 巷 44 號

電話：04-22208589

印次：2021 年 4 月第一次印刷

印數：5000 冊

責任編輯：冷先鋒

責任印製：冷修寧

版面設計：明栩成

圖片攝影：陳璐

網站：hkiwa.com

Email: hkiwa2021@gmail.com